W9-AAP-482

Let's Draw with Shapes™

Let's Draw a
House with Shapes

Joanne Randolph
Illustrations by Emily Muschinske

Discarded by MVCL

The Rosen Publishing Group's
PowerStart Press™
New York

MOUNT VERNON CITY LIBRARY
315 SNOQUALMIE
MOUNT VERNON, WA 98273

Published in 2005 by The Rosen Publishing Group, Inc.
29 East 21st Street, New York, NY 10010

Copyright © 2005 by The Rosen Publishing Group, Inc.

All rights reserved. No part of this book may be reproduced in any form without permission in writing from the publisher, except by a reviewer.

First Edition

Book Design: Emily Muschinske

Photo Credits: p. 23 © Royalty-Free/CORBIS.

Library of Congress Cataloging-in-Publication Data

Randolph, Joanne.
Let's draw a house with shapes / Joanne Randolph.
 p. cm. — (Let's draw with shapes)
ISBN 1-4042-2795-4 (library binding)
1. Buildings in art—Juvenile literature. 2. Drawing—Technique—Juvenile literature. I. Title.
II. Series.

NC825.B8R36 2005
743'.84—dc22
 2004000062

Manufactured in the United States of America

Contents

Draw two big red rectangles
to start your house.

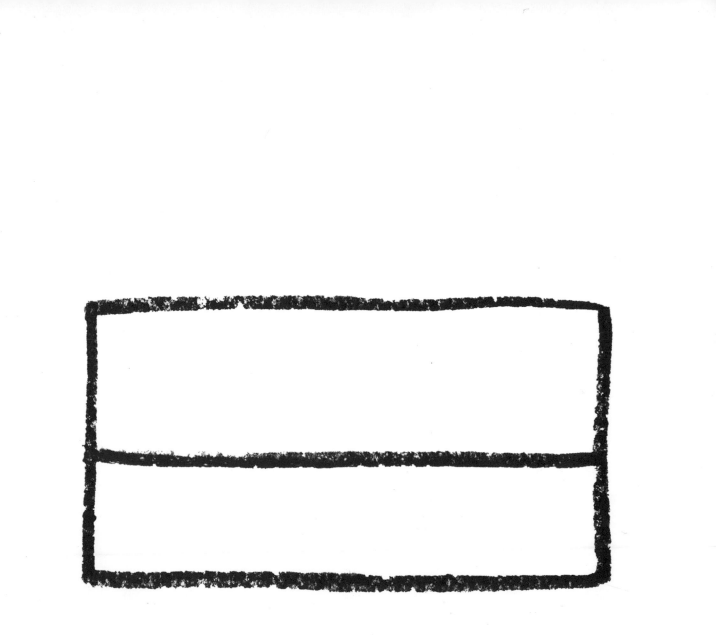

Add an orange triangle for the roof of your house.

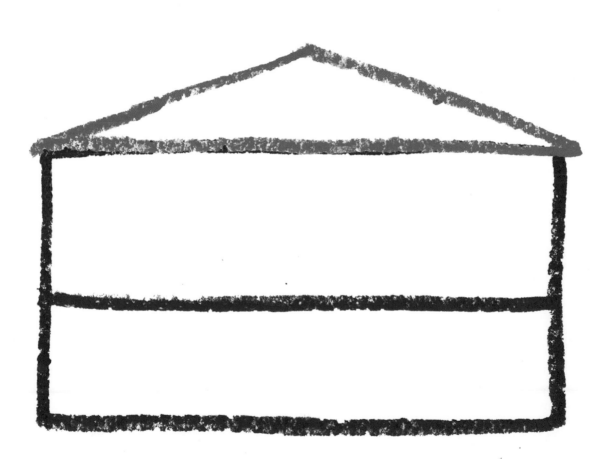

Draw two yellow squares and one yellow rectangle for some windows on your house.

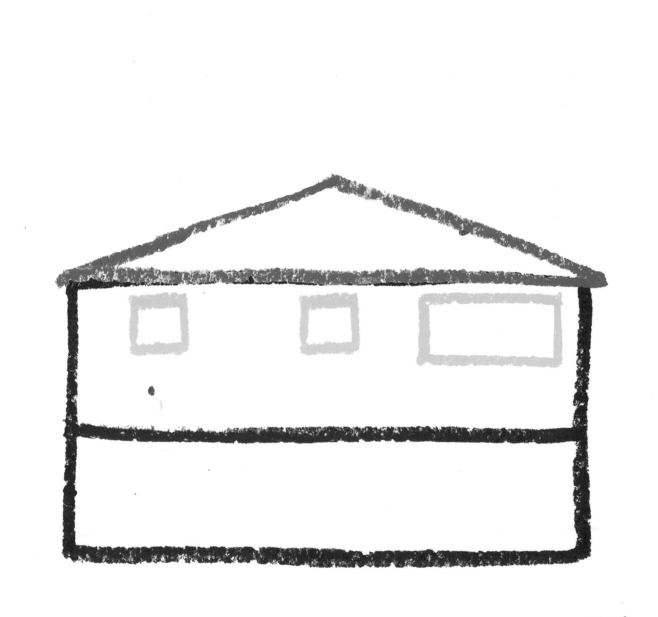

Add two green rectangles for more windows on your house.

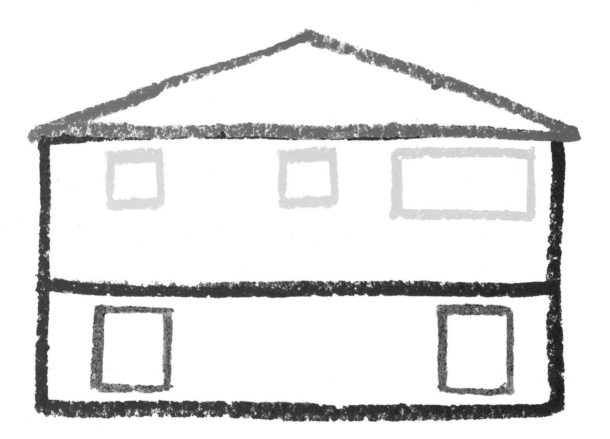

Draw a blue rectangle for the door of your house. Add one blue rectangle on each side of the door for posts.

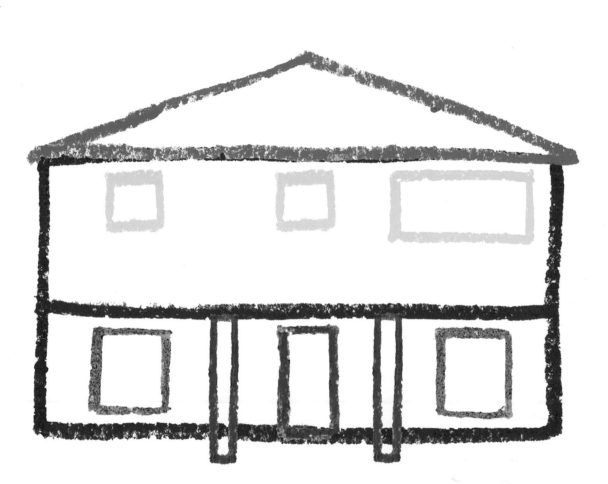

Add a purple triangle above the door of your house. This makes a small roof.

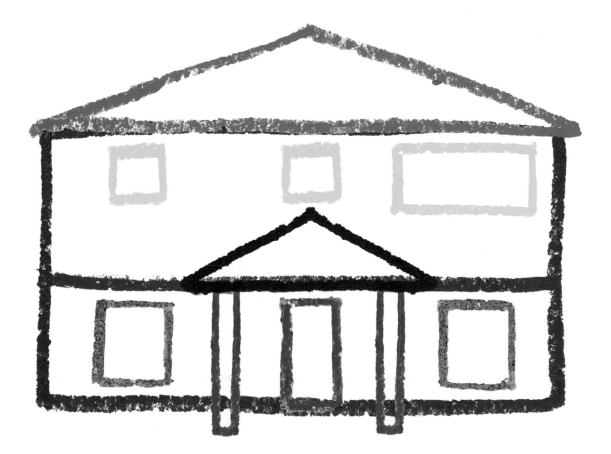

15

Add a pink triangle to the main roof of your house.

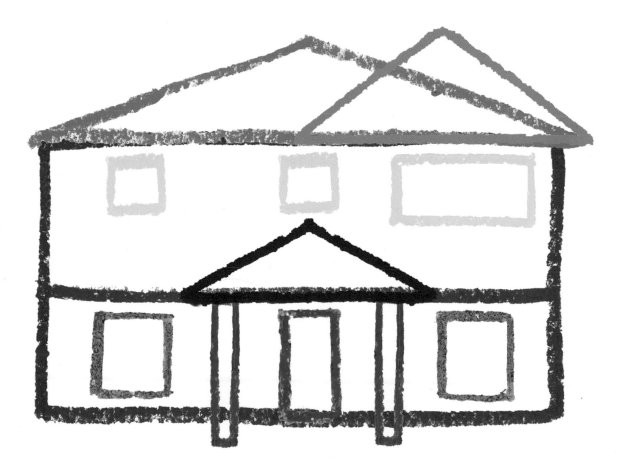

17

Add a black half circle to the
pink triangle. This makes a
new window on your house.

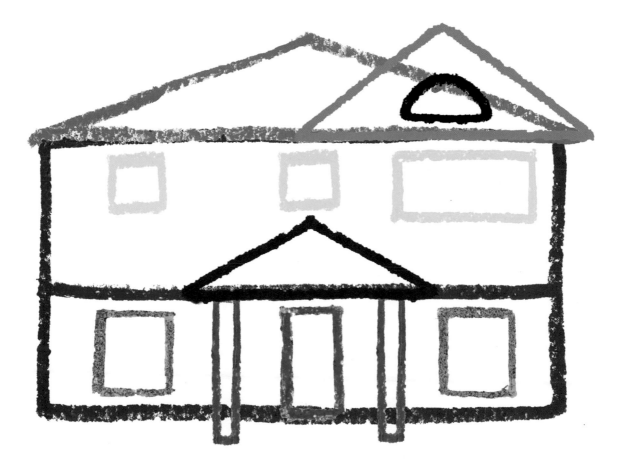

Color in your house.

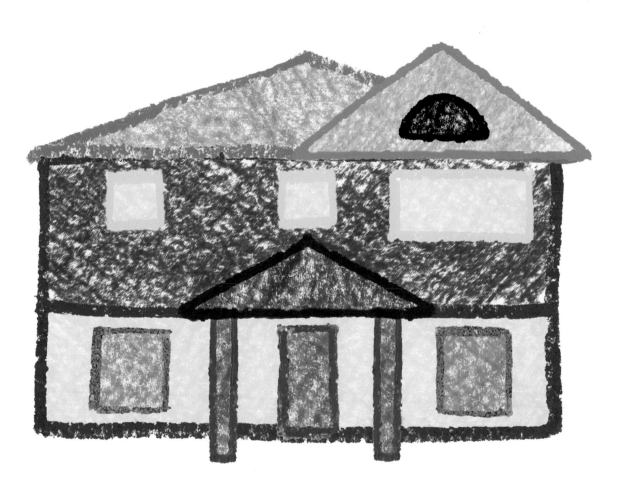

Many people live in houses.

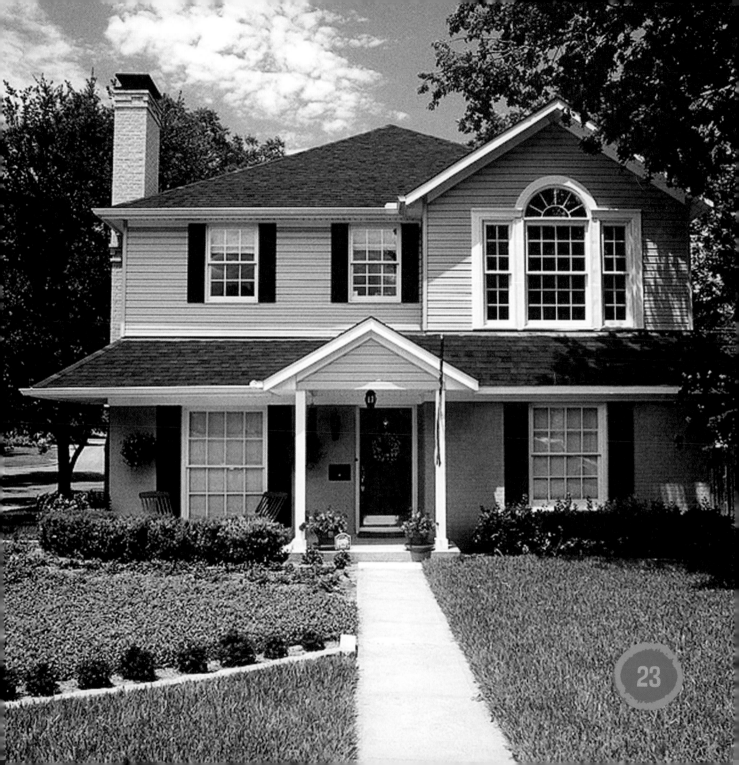

Words to Know

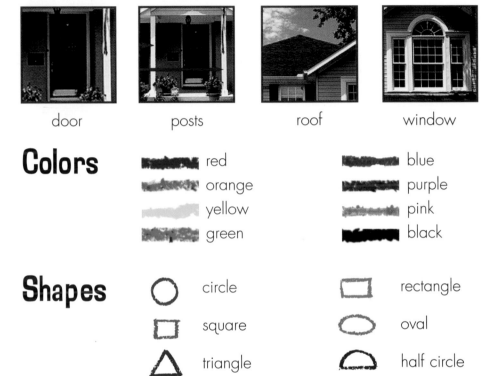

door posts roof window

Colors

red blue
orange purple
yellow pink
green black

Shapes

○ circle ▭ rectangle
□ square ◯ oval
△ triangle ⌒ half circle

Index

Web Sites

Due to the changing nature of Internet links, PowerStart Press has developed an online list of Web sites related to the subject of this book. This site is updated regularly. Please use this link to access the list:

www.powerkidslinks.com/lds/house/

24